EX
LIBRIS

Songs of Innocence

by

William

Blake

Dover Publications, Inc., New York

Published in Canada by General Publishing Company, Ltd., 30 Lesmill Road, Don Mills, Toronto, Ontario.
Published in the United Kingdom by Constable and Company, Ltd., 10 Orange Street, London WC 2.

This Dover edition, first published in 1971, is an unabridged republication of the 1789 edition from the copy in the Lessing J. Rosenwald Collection in the Library of Congress. A Publisher's Note, contents, and complete printed text of the poems have been added for the Dover edition.

International Standard Book Number:
(Clothbound) 0-486-21395-1
(Paperbound) 0-486-22764-2
Library of Congress Catalog Card Number:70-165396

Manufactured in the United States of America
Dover Publications, Inc.
180 Varick Street
New York, N. Y. 10014

Publisher's Note

IN 1789 William Blake, a London journeyman engraver barely thirty, printed the plates of a most unusual book. The first of his "Illuminated Books," *Songs of Innocence* consisted of thirty-one color plates facing one another on 17 sheets, approximately the size of the present volume. In its contents, on nearly every page, poetry and design seemed to be strangely intermixed, so that one hardly knew where poetry ended and design began.

The origin of the book was no less interesting. For some time Blake had been searching for a suitable form for the presentation of his poems. The solution, according to his own account, was supplied by his brother Robert, who had died two years before and dictated the method now in a dream. Both poem and design were to be engraved on a copperplate; then each copy of the book was to be colored with washes by hand. No two copies of the book were to be identical; even the order of the pages was not fixed.

After 1794 Blake expanded the book to include *Songs of Experience,* enlarging the format and darkening the coloring. At that time six plates from the earlier work were transferred to *Songs of Experience.*

The copy of *Songs of Innocence* reproduced in this Dover edition is from the Lessing J. Rosenwald Collection in the Library of Congress (scholars will recognize it as Copy B in the *Census of Blake's Illuminated Books* published by The Grolier Club in 1953). The light coloring indicates that the book, one of some twenty extant copies, was published about 1790.

The Dover edition contains all thirty-one of Blake's original color plates for *Songs of Innocence,* and presents them in the manner of the early copies, on facing color pages. To our knowledge this is the first facsimile which has thus presented color pages in Blake's original format.

To add to the enjoyment of the reader, a printed text of the poems has been added at the end of the volume. The text retains Blake's archaic spellings and unconventional capitalization, but uses the necessary punctuation of Blake's modern editors. Page numbers have been added for identification of the plates.

The publisher is deeply grateful to Mr. Lessing J. Rosenwald, donor of the book to the Library of Congress, for allowing it to be presented in facsimile. Through his cooperation many readers will be able for the first time to experience Blake's poems in the manner in which he intended them.

Contents

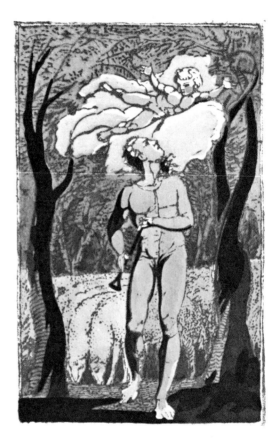

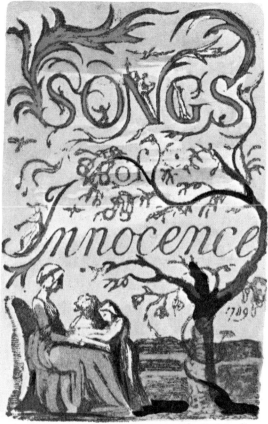

The Author & Printer W Blake

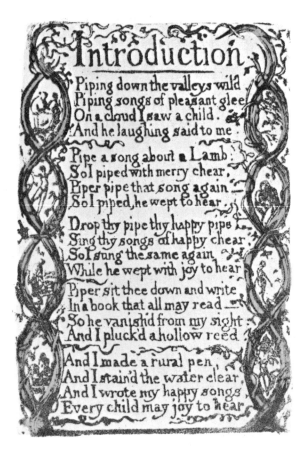

Introduction

Piping down the valleys wild
Piping songs of pleasant glee
On a cloud I saw a child.
And he laughing said to me

Pipe a song about a Lamb:
So I piped with merry chear,
Piper pipe that song again—
So I piped, he wept to hear.

Drop thy pipe thy happy pipe
Sing thy songs of happy chear,
So I sung the same again
While he wept with joy to hear

Piper sit thee down and write
In a book that all may read—
So he vanish'd from my sight
And I pluck'd a hollow reed.

And I made a rural pen,
And I stain'd the water clear
And I wrote my happy songs
Every child may joy to hear

The Shepherd

How sweet is the Shepherds sweet lot!
From the morn to the evening he strays:
He shall follow his sheep all the day
And his tongue shall be filled with praise.

For he hears the lambs innocent call.
And he hears the ewes tender reply.
He is watchful while they are in peace,
For they know when their Shepherd is nigh.

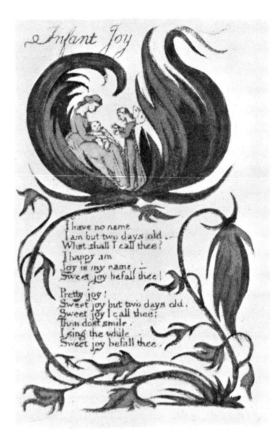

Infant Joy

I have no name
I am but two days old.—
What shall I call thee?
I happy am
Joy is my name,—
Sweet joy befall thee!

Pretty joy!
Sweet joy but two days old.
Sweet joy I call thee;
Thou dost smile.
I sing the while
Sweet joy befall thee.

On Anothers Sorrow

Can I see anothers woe.
And not be in sorrow too.
Can I see anothers grief
And not seek for kind relief.

Can I see a falling tear.
And not feel my sorrows share,
Can a father see his child.
Weep, nor be with sorrow fill'd.

Can a mother sit and hear,
An infant groan an infant fear—
No no never can it be.
Never never can it be.

And can he who smiles on all
Hear the wren with sorrows small.
Hear the small birds grief & care
Hear the woes that infants bear—

And not sit beside the nest
Pouring pity in their breast.
And not sit the cradle near
Weeping tear on infants tear.

And not sit both night & day.
Wiping all our tears away.
O! no never can it be.
Never never can it be.

He doth give his joy to all.
He becomes an infant small.
He becomes a man of woe
He doth feel the sorrow too.

Think not thou canst sigh a sigh,
And thy maker is not by.
Think not thou canst weep a tear,
And thy maker is not near.

O! he gives to us his joy.
That our grief he may destroy
Till our grief is fled & gone
He doth sit by us and moan

7

The School Boy

I love to rise in a summer morn,
When the birds sing on every tree;
The distant huntsman winds his horn,
And the sky-lark sings with me.
O! what sweet company.

But to go to school in a summer morn,
O! it drives all joy away;
Under a cruel eye outworn,
The little ones spend the day,
In sighing and dismay.

Ah! then at times I drooping sit,
And spend many an anxious hour.
Nor in my book can I take delight,
Nor sit in learnings bower,
Worn thro' with the dreary shower.

How can the bird that is born for joy,
Sit in a cage and sing.
How can a child when fears annoy,
But droop his tender wing.
And forget his youthful spring.

O! father & mother, if buds are nip'd,
And blossoms blown away,
And if the tender plants are strip'd
Of their joy in the springing day,
By sorrow and cares dismay.

How shall the summer arise in joy,
Or the summer fruits appear.
Or how shall we gather what griefs destroy
Or bless the mellowing year.
When the blasts of winter appear.

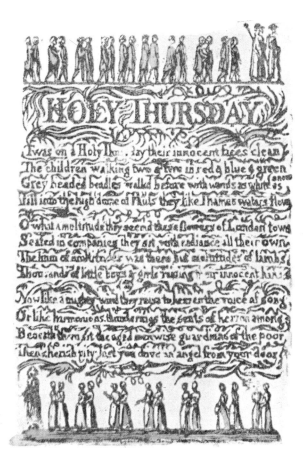

HOLY THURSDAY

Twas on a Holy Thursday their innocent faces clean
The children walking two & two in red & blue & green
Grey headed beadles walkd before with wands as white as snow
Till into the high dome of Pauls they like Thames waters flow

O what a multitude they seemd these flowers of London town
Seated in companies they sit with radiance all their own
The hum of multitudes was there but multitudes of lambs
Thousands of little boys & girls raising their innocent hands

Now like a mighty wind they raise to heaven the voice of song
Or like harmonious thunderings the seats of heaven among
Beneath them sit the aged men wise guardians of the poor
Then cherish pity lest you drive an angel from your door

9

Nurses Song

When the voices of children are heard on the green
And laughing is heard on the hill
My heart is at rest within my breast
And every thing else is still

Then come home my children the sun is gone down
And the dews of night arise
Come come leave off play, and let us away
Till the morning appears in the skies

No no let us play, for it is yet day
And we cannot go to sleep
Besides in the sky, the little birds fly
And the hills are all covered with sheep

Well well go & play till the light fades away
And then go home to bed
The little ones leaped & shouted & laughd
And all the hills eccohed

Laughing Song.

When the green woods laugh with the voice of joy
And the dimpling stream runs laughing by,
When the air does laugh with our merry wit,
And the green hill laughs with the noise of it.

When the meadows laugh with lively green
And the grasshopper laughs in the merry scene,
When Mary and Susan and Emily.
With their sweet round mouths sing Ha Ha He.

When the painted birds laugh in the shade
Where our table with cherries and nuts is spread
Come live & be merry and join with me,
To sing the sweet chorus of Ha Ha He.

The Little Black Boy

My mother bore me in the southern wild,
And I am black, but O! my soul is white.
White as an angel is the English child:
But I am black as if bereav'd of light.

My mother taught me underneath a tree
And sitting down before the heat of day,
She took me on her lap and kissed me.
And pointing to the east began to say.

Look on the rising sun: there God does live
And gives his light, and gives his heat away.
And flowers and trees and beasts and men recieve
Comfort in morning joy in the noon day.

And we are put on earth a little space
That we may learn to bear the beams of love,
And these black bodies and this sun-burnt face
Is but a cloud and like a shady grove.

For

12

For when our souls have learn'd the heat to bear
The cloud will vanish we shall hear his voice.
Saying: come out from the grove my love & care,
And round my golden tent like lambs rejoice.

Thus did my mother say and kissed me.
And thus I say to little English boy.
When I from black and he from white cloud free,
And round the tent of God like lambs we joy:

Ill shade him from the heat till he can bear,
To lean in joy upon our fathers knee.
And then Ill stand and stroke his silver hair,
And be like him and he will then love me.

The Voice of the Ancient Bard.

Youth of delight come hither.
And see the opening morn,
Image of truth new born.
Doubt is fled & clouds of reason,
Dark disputes & artful teazing,
Folly is an endless maze,
Tangled roots perplex her ways,
How many have fallen there!
They stumble all night over bones of the dead;
And feel they know not what but care;
And wish to lead others when they should be led.

The Ecchoing Green

The Sun does arise,
And make happy the skies.
The merry bells ring,
To welcome the Spring.
The sky-lark and thrush,
The birds of the bush,
Sing louder around,
To the bells chearful sound.
While our sports shall be seen
On the Ecchoing Green.

Old John with white hair
Does laugh away care.
Sitting under the oak,
Among the old folk,

They

They laugh at our play,
And soon they all say.
Such, such were the joys.
When we all girls & boys,
In our youth time were seen,
On the Ecchoing Green.

Till the little ones weary
No more can be merry
The sun does descend.
And our sports have an end:
Round the laps of their mothers,
Many sisters and brothers,
Like birds in their nest,
Are ready for rest:
And sport no more seen,
On the darkening Green.

The Chimney Sweeper

When my mother died I was very young,
And my father sold me while yet my tongue,
Could scarcely cry weep weep weep weep.
So your chimneys I sweep & in soot I sleep.

Theres little Tom Dacre who cried when his head
That curld like a lambs back, was shavd, so I said.
Hush Tom never mind it, for when your heads bare,
You know that the soot cannot spoil your white hair

And so he was quiet, & that very night.
As Tom was a sleeping he had such a sight
That thousands of sweepers Dick, Joe, Ned & Jack
Were all of them lock'd up in coffins of black,

And by came an Angel who had a bright key,
And he opend the coffins & set them all free.
Then down a green plain leaping laughing they run
And wash in a river and shine in the Sun.

Then naked & white, all their bags left behind.
They rise upon clouds, and sport in the wind.
And the Angel told Tom if he'd be a good boy,
He'd have God for his father & never want joy.

And so Tom awoke and we rose in the dark
And got with our bags & our brushes to work.
Tho the morning was cold, Tom was happy & warm,
So if all do their duty, they need not fear harm.

The Divine Image.

To Mercy Pity Peace and Love.
All pray in their distress:
And to these virtues of delight
Return their thankfulness.

For Mercy Pity Peace and Love,
Is God our father dear:
And Mercy Pity Peace and Love,
Is Man his child and care.

For Mercy has a human heart
Pity, a human face:
And Love, the human form divine,
And Peace, the human dress.

Then every man of every clime,
That prays in his distress,
Prays to the human form divine
Love Mercy Pity Peace.

And all must love the human form,
In heathen, turk or jew.
Where Mercy, Love & Pity dwell
There God is dwelling too.

A Dream

Once a dream did weave a shade.
O'er my Angel-guarded bed,
That an Emmet lost its way
Where on grass methought I lay.

Troubled wilderd and folorn
Dark benighted travel-worn.
Over many a tangled spray.
All heart-broke I heard her say.

O my children! do they cry?
Do they hear their father sigh.
Now they look abroad to see,
Now return and weep for me.

Pitying I dropd a tear:
But I saw a glow-worm near:
Who replied. What wailing wight
Calls the watchman of the night.

I am set to light the ground,
While the beetle goes his round:
Follow now the beetles hum.
Little wanderer hie thee home

19

The Little Girl Lost

In futurity
I prophetic see.
That the earth from sleep,
(Grave the sentence deep)

Shall arise and seek
For her maker meek:
And the desert wild
Become a garden mild.

In the southern clime,
Where the summers prime,
Never fades away;
Lovely Lyca lay.

Seven summers old
Lovely Lyca told
She had wanderd long,
Hearing wild birds song.

Sweet sleep come to me
Underneath this tree;
Do father, mother weep.—
Where can Lyca sleep.

Lost in desart wild
Is your little child.
How can Lyca sleep,
If her mother weep.

If her heart does ake,
Then let Lyca wake;
If my mother sleep,
Lyca shall not weep.

Frowning frowning night,
O'er this desart bright.
Let thy moon arise,
While I close my eyes.

Sleeping Lyca lay;
While the beasts of prey,
Come from caverns deep,
View'd the maid asleep

The kingly lion stood
And the virgin viewd.
Then he gambold round
O'er the hallowd ground

Leopards, tygers play,
Round her as she lay;
While the lion old,
Bow'd his mane of gold.

And her bosom lick,
And upon her neck,
From his eyes of flame,
Ruby tears there came;

While the lioness
Loos'd her slender dress,
And naked they convey'd
To caves the sleeping maid.

The Little Girl Found

All the night in woe,
Lyca's parents go:
Over vallies deep,
While the deserts weep.

Tired and woe-begone,
Hoarse with making moan,
Arm in arm seven days,
They trac'd the desart ways.

Seven nights they sleep,
Among shadows deep:
And dream they see their child
Starv'd in desart wild.

Pale thro' pathless ways
The fancied image strays,

Frighted

Famish'd, weeping, weak
With hollow piteous shriek

Rising from unrest,
The trembling woman prest,
With feet of weary woe;
She could no further go.

In his arms he bore,
Her arm'd with sorrow sore:
Till before their way,
A couching lion lay.

Turning back was vain,
Soon his heavy mane
Bore them to the ground;
Then he stalk'd around.

Smelling to his prey,
But their fears allay,
When he licks their hands;
And silent by them stands.

They look upon his eyes
Fill'd with deep surprise:
And wondering behold,
A spirit arm'd in gold.

On his head a crown;
On his shoulders down,
Flow'd his golden hair.
Gone was all their care.

Follow me he said,
Weep not for the maid;
In my palace deep,
Lyca lies asleep.

Then they followed,
Where the vision led:
And saw their sleeping child,
Among tygers wild.

To this day they dwell
In a lonely dell
Nor fear the wolvish howl,
Nor the lions growl.

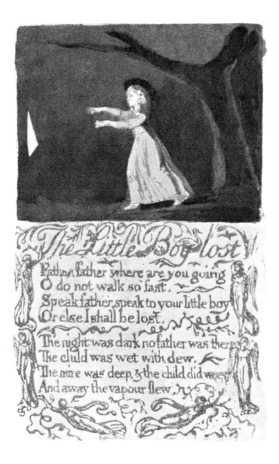

The Little Boy lost

Father, father where are you going
O do not walk so fast.
Speak father, speak to your little boy
Or else I shall be lost.

The night was dark no father was there
The child was wet with dew.
The mire was deep, & the child did weep
And away the vapour flew.

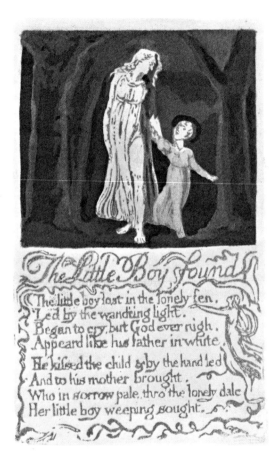

The Little Boy found

The little boy lost in the lonely fen,
Led by the wandring light,
Began to cry, but God ever nigh,
Appeard like his father in white.

He kissed the child & by the hand led
And to his mother brought,
Who in sorrow pale. thro' the lonely dale
Her little boy weeping sought.

A CRADLE SONG

Sweet dreams form a shade,
O'er my lovely infants head,
Sweet dreams of pleasant streams,
By happy silent moony beams

Sweet sleep with soft down,
Weave thy brows an infant crown,
Sweet sleep Angel mild,
Hover o'er my happy child,

Sweet smiles in the night,
Hover over my delight,
Sweet smiles Mothers smiles,
All the livelong night beguiles,

Sweet moans, dovelike sighs,
Chase not slumber from thy eyes,
Sweet moans, sweeter smiles,
All the dovelike moans beguiles,

Sleep sleep happy child,
All creation slept and smild,
Sleep sleep, happy sleep,
While o'er thee thy mother weep

Sweet babe in thy face,
Holy image I can trace,
Sweet babe once like thee,
Thy maker lay and wept for me

Wept

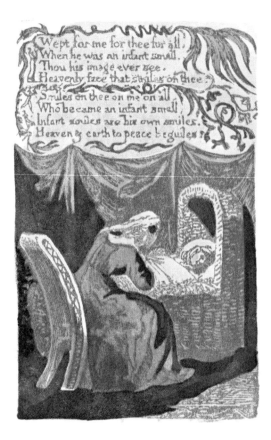

Wept for me for thee for all,
When he was an infant small.
Thou his image ever see.
Heavenly face that smiles on thee,

Smiles on thee on me on all
Who became an infant small
Infant smiles are his own smiles.
Heaven & earth to peace beguiles

Spring

Sound the Flute!
Now it's mute.
Birds delight
Day and Night.
Nightingale
In the dale
Lark in Sky
Merrily
Merrily Merrily to welcome in the (Year

Little Boy
Full of joy.

Little

Little Girl
Sweet and small,
Cock does crow
So do you.
Merry voice
Infant noise
Merrily Merrily to welcome in the Year

Little Lamb
Here I am,
Come and lick
My white neck.
Let me pull
Your soft Wool.
Let me kiss
Your soft face. Year
Merrily Merrily we welcome in the

28

The Blossom.

Merry Merry Sparrow
Under leaves so green
A happy Blossom
Sees you swift as arrow
Seek your cradle narrow
Near my Bosom.

Pretty Pretty Robin
Under leaves so green
A happy Blossom
Hears you sobbing sobbing
Pretty Pretty Robin
Near my Bosom.

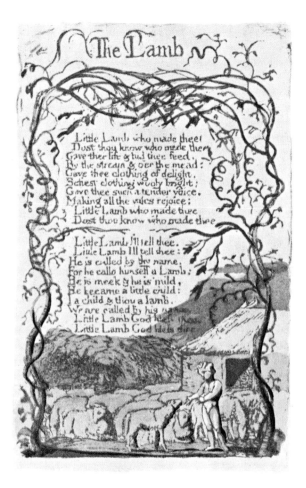

The Lamb

Little Lamb who made thee?
Dost thou know who made thee,
Gave thee life & bid thee feed,
By the stream & o'er the mead;
Gave thee clothing of delight,
Softest clothing wooly bright;
Gave thee such a tender voice,
Making all the vales rejoice;
 Little Lamb who made thee?
 Dost thou know who made thee?

Little Lamb I'll tell thee,
 Little Lamb I'll tell thee:
He is called by thy name,
For he calls himself a Lamb:
He is meek & he is mild,
He became a little child:
I a child & thou a lamb,
We are called by his name,
 Little Lamb God bless thee,
 Little Lamb God bless thee.

Night

The sun descending in the west,
The evening star does shine.
The birds are silent in their nest,
And I must seek for mine.
The moon like a flower,
In heavens high bower:
With silent delight,
Sits and smiles on the night.

Farewell green fields and happy groves,
Where flocks have took delight;
Where lambs have nibbled, silent moves
The feet of angels bright:
Unseen they pour blessing,
And joy without ceasing,
On each bud and blossom,
And each sleeping bosom.

They look in every thoughtless nest,
Where birds are coverd warm;
They visit caves of every beast,
To keep them all from harm:
If they see any weeping,
That should have been sleeping
They pour sleep on their head
And sit down by their bed

When wolves and tygers howl for prey
They pitying stand and weep;
Seeking to drive their thirst away,
And keep them from the sheep.
But if they rush dreadful;
The angels most heedful.
Recieve each mild spirit.
New worlds to inherit.

And there the lions ruddy eyes.
Shall flow with tears of gold.
And pitying the tender cries.
And walking round the fold:
Saying: wrath by his meekness
And by his health. sickness
Is driven away.
From our immortal day.

And now beside thee bleating lamb
I can lie down and sleep;
Or think on him who bore thy name.
Graze after thee and weep.
For washd in lifes river.
My bright mane for ever.
Shall shine like the gold.
As I guard o'er the fold.

Songs
of Innocence

Introduction

Piping down the valleys wild,
Piping songs of pleasant glee,
On a cloud I saw a child,
And he laughing said to me:

"Pipe a song about a Lamb!"
So I piped with merry chear.
"Piper, pipe that song again;"
So I piped, he wept to hear.

"Drop thy pipe, thy happy pipe;
Sing thy songs of happy chear:"
So I sung the same again,
While he wept with joy to hear.

"Piper, sit thee down and write
In a book, that all may read."
So he vanish'd from my sight,
And I pluck'd a hollow reed,

And I made a rural pen,
And I stain'd the water clear,
And I wrote my happy songs
Every child may joy to hear.

How sweet is the Shepherd's sweet lot! *The Shepherd*
From the morn to the evening he strays;
He shall follow his sheep all the day,
And his tongue shall be filled with praise.

For he hears the lamb's innocent call,
And he hears the ewe's tender reply;
He is watchful while they are in peace,
For they know when their Shepherd is nigh.

"I have no name: *Infant Joy*
I am but two days old."
What shall I call thee?
"I happy am,
Joy is my name."
Sweet joy befall thee!

Pretty joy!
Sweet joy, but two days old.
Sweet joy I call thee:
Thou dost smile,
I sing the while,
Sweet joy befall thee!

On Another's Sorrow Can I see another's woe,
And not be in sorrow too?
Can I see another's grief,
And not seek for kind relief?

Can I see a falling tear,
And not feel my sorrow's share?
Can a father see his child
Weep, nor be with sorrow fill'd?

Can a mother sit and hear
An infant groan, an infant fear?
No, no! never can it be!
Never, never can it be!

And can he who smiles on all
Hear the wren with sorrows small,
Hear the small bird's grief & care,
Hear the woes that infants bear,

And not sit beside the nest,
Pouring pity in their breast;
And not sit the cradle near,
Weeping tear on infant's tear;

And not sit both night & day,
Wiping all our tears away?
O! no, never can it be!
Never, never can it be!

He doth give his joy to all;
He becomes an infant small;
He becomes a man of woe;
He doth feel the sorrow too.

Think not thou canst sigh a sigh,
And thy maker is not by;
Think not thou canst weep a tear,
And thy maker is not near.

O! he gives to us his joy
That our grief he may destroy;
Till our grief is fled & gone
He doth sit by us and moan.

I love to rise in a summer morn *The School Boy*
When the birds sing on every tree;
The distant huntsman winds his horn,
And the sky-lark sings with me.
O! what sweet company.

But to go to school in a summer morn,
O! it drives all joy away;
Under a cruel eye outworn,
The little ones spend the day
In sighing and dismay.

Ah! then at times I drooping sit,
And spend many an anxious hour,
Nor in my book can I take delight,
Nor sit in learning's bower,
Worn thro' with the dreary shower.

How can the bird that is born for joy
Sit in a cage and sing?
How can a child, when fears annoy,
But droop his tender wing,
And forget his youthful spring?

O! father & mother, if buds are nip'd
And blossoms blown away,
And if the tender plants are strip'd
Of their joy in the springing day,
By sorrow and care's dismay,

How shall the summer arise in joy,
Or the summer fruits appear?
Or how shall we gather what griefs destroy,
Or bless the mellowing year,
When the blasts of winter appear?

Holy
Thursday
'Twas on a Holy Thursday, their innocent faces clean,
The children walking two & two, in red & blue & green,
Grey-headed beadles walk'd before, with wands as white as snow,
Till into the high dome of Paul's they like Thames' waters flow.

O what a multitude they seem'd, these flowers of London town!
Seated in companies they sit with radiance all their own.
The hum of multitudes was there, but multitudes of lambs,
Thousands of little boys & girls raising their innocent hands.

Now like a mighty wind they raise to heaven the voice of song,
Or like harmonious thunderings the seats of heaven among.
Beneath them sit the aged men, wise guardians of the poor;
Then cherish pity, lest you drive an angel from your door.

When the voices of children are heard on the green, *Nurse's Song*
And laughing is heard on the hill,
My heart is at rest within my breast,
And everything else is still.

"Then come home, my children, the sun is gone down,
And the dews of night arise;
Come, come, leave off play, and let us away
Till the morning appears in the skies."

"No, no, let us play, for it is yet day,
And we cannot go to sleep;
Besides, in the sky the little birds fly,
And the hills are all cover'd with sheep."

"Well, well, go & play till the light fades away,
And then go home to bed."
The little ones leaped & shouted & laugh'd
And all the hills ecchoed.

Laughing
Song

When the green woods laugh with the voice of joy,
And the dimpling stream runs laughing by;
When the air does laugh with our merry wit,
And the green hill laughs with the noise of it;

When the meadows laugh with lively green,
And the grasshopper laughs in the merry scene,
When Mary and Susan and Emily
With their sweet round mouths sing "Ha, Ha, He!"

When the painted birds laugh in the shade,
Where our table with cherries and nuts is spread,
Come live & be merry, and join with me,
To sing the sweet chorus of "Ha, Ha, He!"

The Little
Black Boy

My mother bore me in the southern wild,
And I am black, but O! my soul is white;
White as an angel is the English child,
But I am black as if bereav'd of light.

My mother taught me underneath a tree,
And, sitting down before the heat of day,
She took me on her lap and kissed me,
And pointing to the east began to say:

"Look on the rising sun: there God does live,
And gives his light, and gives his heat away;
And flowers and trees and beasts and men recieve
Comfort in morning, joy in the noonday.

"And we are put on earth a little space,
That we may learn to bear the beams of love;
And these black bodies and this sunburnt face
Is but a cloud, and like a shady grove.

"For when our souls have learn'd the heat to bear,
The cloud will vanish; we shall hear his voice,
Saying: 'Come out from the grove, my love & care,
And round my golden tent like lambs rejoice.' "

Thus did my mother say, and kissed me;
And thus I say to little English boy.
When I from black and he from white cloud free,
And round the tent of God like lambs we joy,

I'll shade him from the heat, till he can bear
To lean in joy upon our father's knee;
And then I'll stand and stroke his silver hair,
And be like him, and he will then love me.

Youth of delight, come hither, *The Voice of the*
And see the opening morn, *Ancient Bard*
Image of truth new-born.
Doubt is fled & clouds of reason,
Dark disputes & artful teazing.
Folly is an endless maze,
Tangled roots perplex her ways.
How many have fallen there!
They stumble all night over bones of the dead,
And feel they know not what but care,
And wish to lead others, when they should be led.

The Ecchoing Green
The Sun does arise,
And make happy the skies;
The merry bells ring
To welcome the Spring;
The sky-lark and thrush,
The birds of the bush,
Sing louder around
To the bells' chearful sound,
While our sports shall be seen
On the Ecchoing Green.

Old John, with white hair,
Does laugh away care,
Sitting under the oak,
Among the old folk.
They laugh at our play,
And soon they all say:
"Such, such were the joys
When we all, girls & boys,
In our youth time were seen
On the Ecchoing Green."

Till the little ones, weary,
No more can be merry;
The sun does descend,
And our sports have an end.
Round the laps of their mothers
Many sisters and brothers,
Like birds in their nest,
Are ready for rest,
And sport no more seen
On the darkening Green.

When my mother died I was very young,
And my father sold me while yet my tongue
Could scarcely cry " 'weep! 'weep! 'weep! 'weep!"
So your chimneys I sweep & in soot I sleep.

There's little Tom Dacre, who cried when his head,
That curl'd like a lamb's back, was shav'd: so I said
"Hush, Tom! never mind it, for when your head's bare
You know that the soot cannot spoil your white hair."

And so he was quiet & that very night,
As Tom was a-sleeping, he had such a sight!
That thousands of sweepers, Dick, Joe, Ned & Jack,
Were all of them lock'd up in coffins of black.

And by came an Angel who had a bright key,
And he open'd the coffins & set them all free;
Then down a green plain leaping, laughing, they run,
And wash in a river, and shine in the Sun.

Then naked & white, all their bags left behind,
They rise upon clouds and sport in the wind;
And the Angel told Tom, if he'd be a good boy,
He'd have God for his father & never want joy.

And so Tom awoke; and we rose in the dark,
And got with our bags & our brushes to work.
Tho' the morning was cold, Tom was happy & warm;
So if all do their duty they need not fear harm.

The Divine Image

To Mercy, Pity, Peace, and Love
All pray in their distress;
And to these virtues of delight
Return their thankfulness.

For Mercy, Pity, Peace, and Love
Is God, our father dear,
And Mercy, Pity, Peace, and Love
Is Man, his child and care.

For Mercy has a human heart,
Pity a human face,
And Love, the human form divine,
And Peace, the human dress.

Then every man, of every clime
That prays in his distress,
Prays to the human form divine,
Love, Mercy, Pity, Peace.

And all must love the human form,
In heathen, turk, or jew;
Where Mercy, Love & Pity dwell
There God is dwelling too.

A Dream

Once a dream did weave a shade
O'er my Angel-guarded bed,
That an Emmet lost its way
Where on grass methought I lay.

Troubled, 'wilder'd, and forlorn,
Dark, benighted, travel-worn,
Over many a tangled spray,
All heart-broke I heard her say:

"O, my children! do they cry?
Do they hear their father sigh?
Now they look abroad to see:
Now return and weep for me."

Pitying, I drop'd a tear;
But I saw a glow-worm near,
Who replied: "What wailing wight
Calls the watchman of the night?

"I am set to light the ground,
While the beetle goes his round:
Follow now the beetle's hum;
Little wanderer, hie thee home."




In futurity
I prophetic see
That the earth from sleep
(Grave the sentence deep)

Shall arise and seek
For her maker meek;
And the desart wild
Become a garden mild.




The Little Girl Lost




In the southern clime,
Where the summer's prime
Never fades away,
Lovely Lyca lay.

Seven summers old
Lovely Lyca told;
She had wander'd long
Hearing wild birds' song.

"Sweet sleep, come to me
Underneath this tree.
Do father, mother, weep?
Where can Lyca sleep?

"Lost in desart wild
Is your little child.
How can Lyca sleep
If her mother weep?

"If her heart does ake
Then let Lyca wake;
If my mother sleep,
Lyca shall not weep.

"Frowning, frowning night,
O'er this desart bright,
Let thy moon arise
While I close my eyes."

Sleeping Lyca lay
While the beasts of prey,
Come from caverns deep,
View'd the maid asleep.

The kingly lion stood,
And the virgin view'd,
Then he gambol'd round
O'er the hallow'd ground.

Leopards, tygers, play
Round her as she lay,
While the lion old
Bow'd his mane of gold

And her bosom lick,
And upon her neck
From his eyes of flame
Ruby tears there came;

While the lioness
Loos'd her slender dress,
And naked they convey'd
To caves the sleeping maid.

The Little Girl Found

All the night in woe
Lyca's parents go
Over vallies deep,
While the desarts weep.

Tired and woe-begone,
Hoarse with making moan,
Arm in arm seven days
They trac'd the desart ways.

Seven nights they sleep
Among shadows deep,
And dream they see their child
Starv'd in desart wild.

Pale, thro' pathless ways
The fancied image strays
Famish'd, weeping, weak,
With hollow piteous shriek.

Rising from unrest,
The trembling woman prest
With feet of weary woe:
She could no further go.

In his arms he bore
Her, arm'd with sorrow sore;
Till before their way
A couching lion lay.

Turning back was vain:
Soon his heavy mane
Bore them to the ground.
Then he stalk'd around,

Smelling to his prey;
But their fears allay
When he licks their hands,
And silent by them stands.

They look upon his eyes
Fill'd with deep surprise;
And wondering behold
A Spirit arm'd in gold.

On his head a crown;
On his shoulders down
Flow'd his golden hair.
Gone was all their care.

"Follow me," he said;
"Weep not for the maid;
In my palace deep
Lyca lies asleep."

Then they followed
Where the vision led,
And saw their sleeping child
Among tygers wild.

To this day they dwell
In a lonely dell;
Nor fear the wolvish howl
Nor the lions' growl.

"Father! father! where are you going?
O do not walk so fast.
Speak, father, speak to your little boy,
Or else I shall be lost."

The Little Boy Lost

The night was dark, no father was there;
The child was wet with dew;
The mire was deep, & the child did weep,
And away the vapour flew.

The Little
Boy Found

The little boy lost in the lonely fen,
Led by the wand'ring light,
Began to cry; but God, ever nigh,
Appear'd like his father, in white.

He kissed the child, & by the hand led,
And to his mother brought,
Who in sorrow pale, thro' the lonely dale,
Her little boy weeping sought.

A Cradle Song

Sweet dreams form a shade
O'er my lovely infant's head;
Sweet dreams of pleasant streams
By happy, silent, moony beams.

Sweet sleep with soft down
Weave thy brows an infant crown.
Sweet sleep, Angel mild,
Hover o'er my happy child.

Sweet smiles in the night
Hover over my delight;
Sweet smiles, Mother's smiles,
All the livelong night beguiles.

Sweet moans, dovelike sighs,
Chase not slumber from thy eyes.
Sweet moans, sweeter smiles,
All the dovelike moans beguiles.

Sleep sleep, happy child,
All creation slept and smil'd;
Sleep sleep, happy sleep,
While o'er thee thy mother weep.

Sweet babe, in thy face
Holy image I can trace.
Sweet babe, once like thee,
Thy maker lay and wept for me,

Wept for me, for thee, for all,
When he was an infant small.
Thou his image ever see,
Heavenly face that smiles on thee,

Smiles on thee, on me, on all;
Who became an infant small.
Infant smiles are his own smiles;
Heaven & earth to peace beguiles.

Sound the Flute! *Spring*
Now it's mute.
Birds delight
Day and Night;
Nightingale
In the dale,
Lark in Sky,
Merrily,
Merrily, Merrily, to welcome in the Year.

Little Boy,
Full of joy;
Little Girl,
Sweet and small;
Cock does crow,
So do you;
Merry voice,
Infant noise,
Merrily, Merrily, to welcome in the Year.

Little Lamb,
Here I am;
Come and lick
My white neck;
Let me pull
Your soft Wool;
Let me kiss
Your soft face:
Merrily, Merrily, we welcome in the Year.

The Blossom

Merry Merry Sparrow!
Under leaves so green,
A happy Blossom
Sees you, swift as arrow,
Seek your cradle narrow
Near my Bosom.

Pretty Pretty Robin!
Under leaves so green,
A happy Blossom
Hears you sobbing, sobbing,
Pretty Pretty Robin,
Near my Bosom.

Little Lamb, who made thee? *The Lamb*
Dost thou know who made thee?
Gave thee life & bid thee feed,
By the stream & o'er the mead;
Gave thee clothing of delight,
Softest clothing, wooly, bright;
Gave thee such a tender voice,
Making all the vales rejoice?
 Little Lamb, who made thee?
 Dost thou know who made thee?

Little Lamb, I'll tell thee,
Little Lamb, I'll tell thee:
He is called by thy name,
For he calls himself a Lamb.
He is meek & he is mild;
He became a little child.
I a child & thou a lamb.
We are called by his name.
 Little Lamb, God bless thee!
 Little Lamb, God bless thee!

Night

The sun descending in the west,
The evening star does shine;
The birds are silent in their nest,
And I must seek for mine.
The moon like a flower,
In heaven's high bower,
With silent delight
Sits and smiles on the night.

Farewell, green fields and happy groves,
Where flocks have took delight;
Where lambs have nibbled, silent moves
The feet of angels bright;
Unseen they pour blessing,
And joy without ceasing,
On each bud and blossom,
And each sleeping bosom.

They look in every thoughtless nest,
Where birds are cover'd warm;
They visit caves of every beast,
To keep them all from harm;
If they see any weeping
That should have been sleeping,
They pour sleep on their head
And sit down by their bed.

When wolves and tygers howl for prey,
They pitying stand and weep;
Seeking to drive their thirst away,
And keep them from the sheep.
But if they rush dreadful,
The angels, most heedful,
Recieve each mild spirit,
New worlds to inherit.

And there the lion's ruddy eyes
Shall flow with tears of gold,
And pitying the tender cries,
And walking round the fold,
Saying "Wrath, by his meekness,
And, by his health, sickness
Is driven away
From our immortal day.

"And now beside thee, bleating lamb,
I can lie down and sleep;
Or think on him who bore thy name,
Graze after thee and weep.
For, wash'd in life's river,
My bright mane for ever
Shall shine like the gold
As I guard o'er the fold."